Frida Kahlo Postcards

Chronicle Books ■ San Francisco

Printed in Hong Kong.

Works by Frida Kahlo are reproduced with permission of
the Instituto Nacional de Bellas Artes, Mexico City,
receipt #43155.

A note to the correspondent: these slightly oversized
postcards require the same postage as a first-class letter.

Selection and Editing by Marquand Books
Design: Cathleen O'Brien

ISBN: 0-8118-0039-3

Distributed in Canada by Raincoast Books,
112 East Third Ave., Vancouver, B.C. V5T 1C8

10 9 8 7 6 5 4 3 2 1

Chronicle Books
275 Fifth Street
San Francisco, California 94103

Introduction to Frida Kahlo Postcards

From *Frida Kahlo: The Brush of Anguish* by Martha Zamora

Frida Kahlo's single most frequent theme was the obsessive self-portrait, in which she appears alone or with her pets or other meaningful possessions. When asked, as she frequently was, why she painted herself so often, she replied, "Porque estoy muy sola" (because I am all alone). Some theorize that she painted herself to ensure she would be remembered. Her former lover and longtime friend Alejandro Gómez Arias suggests that Frida's continual portrait painting was "a recourse, the ultimate means to survive, to endure, to conquer death."

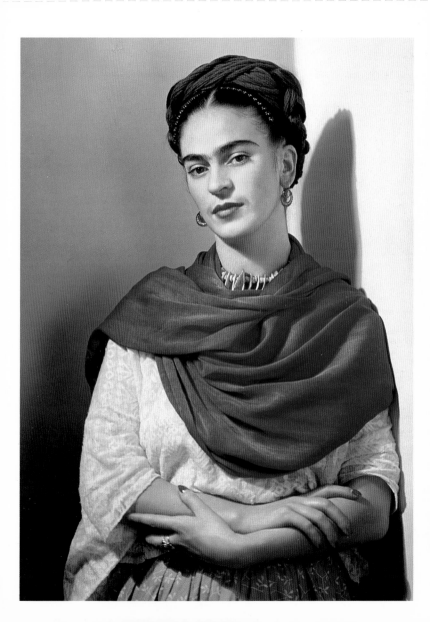

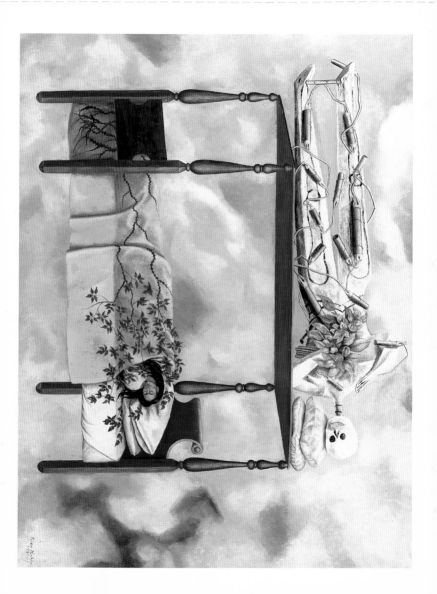

The Dream, 1940
(El sueño)
Oil on canvas, 73 x 98 cm
Private collection

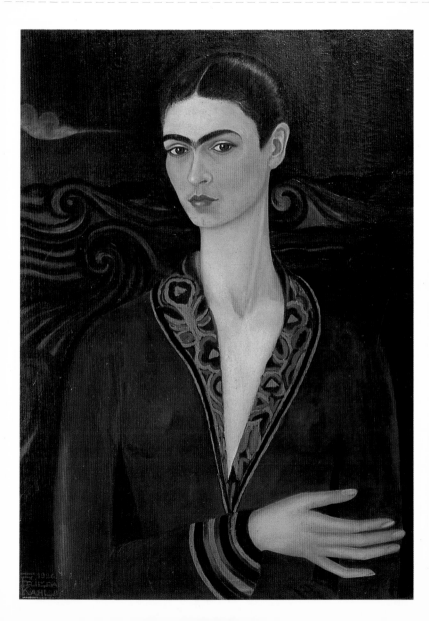

Self-Portrait Wearing a Velvet Dress, 1926
(Autorretrato con traje de terciopelo)
Oil on canvas, 78 x 61 cm
Collection of Alejandro Gómez Arias, Mexico City

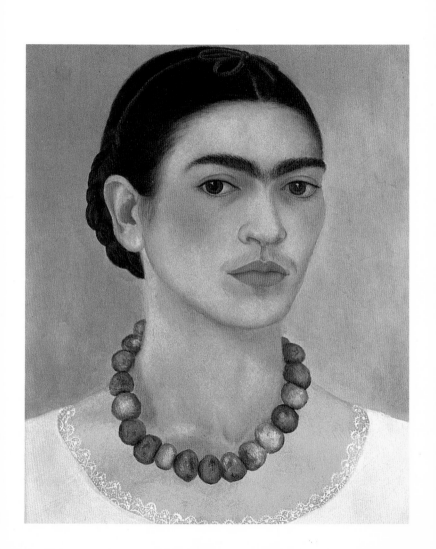

Self-Portrait with Necklace, 1933
(Autorretrato con collar)
Oil on metal, 35 x 30 cm
Jacques and Natasha Gelman Collection

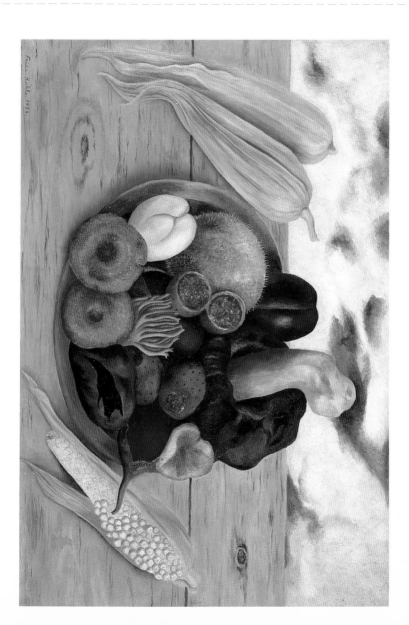

Fruits of the Earth, 1938
(Frutos de la tierra)
Oil on Masonite, 40 x 60 cm
Collection of Banco Nacional de Mexico, Mexico City

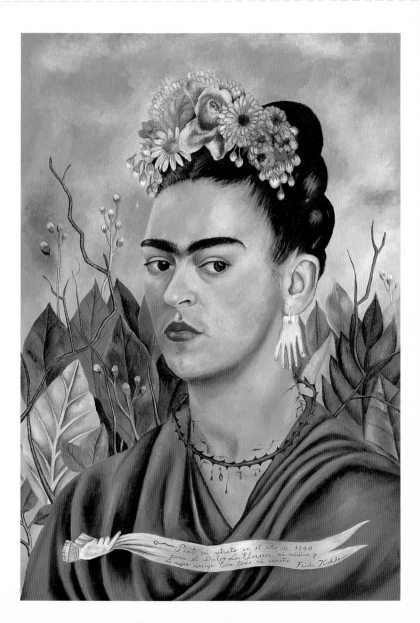

Self-Portrait Dedicated to Dr. Eloesser, 1940
(Autorretrato dedicado al Dr. Eloesser)
Oil on Masonite, 59 x 40 cm
Private collection, U. S. A.

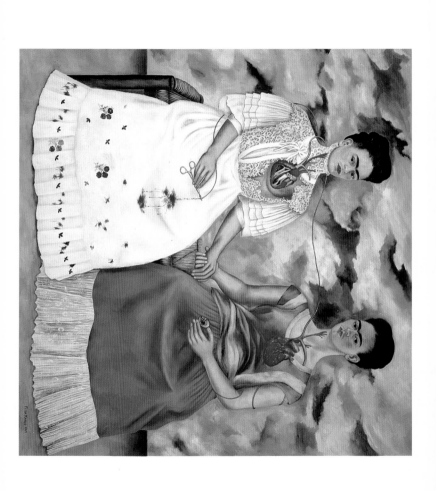

The Two Fridas, 1939
(Las dos Fridas)
Oil on canvas, 173 x 173 cm
Museo de Arte Moderno, Mexico City

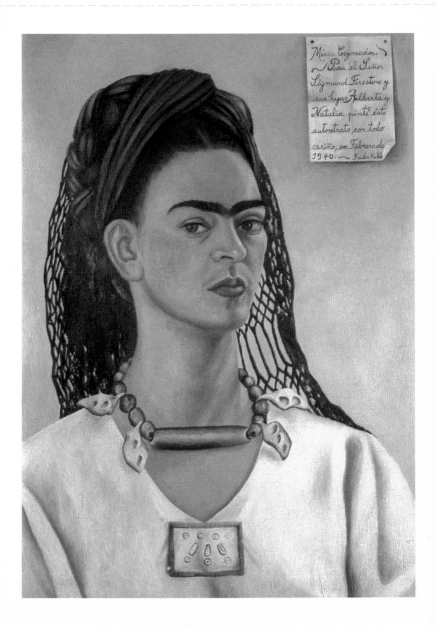

Self-Portrait Dedicated to Sigmund Firestone, 1940
(Autorretrato dedicado a Sigmund Firestone)
Oil on Masonite, 60 x 42 cm
Collection of Violet Gershenson, New York

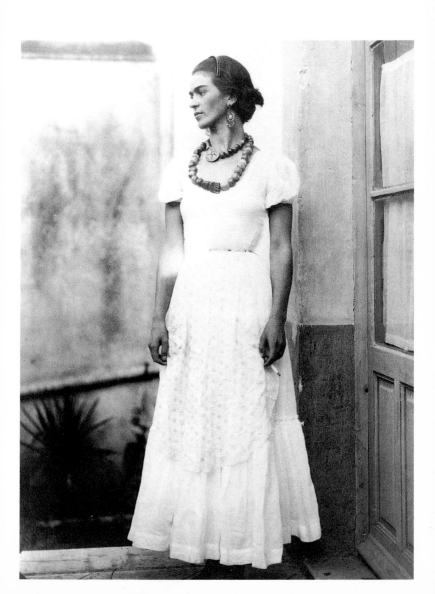

Frida in a white dress

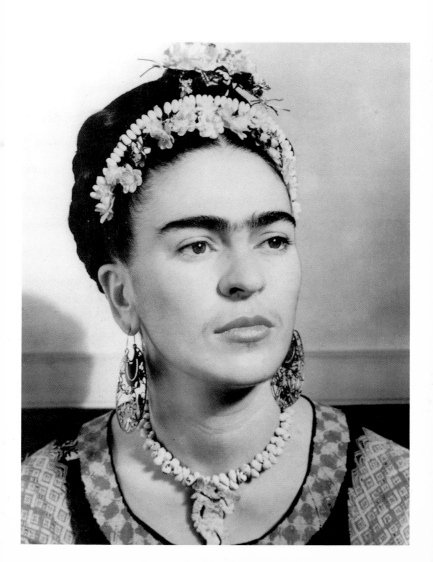

Frida, c. 1943
Photo: Courtesy Guillermo Monroy

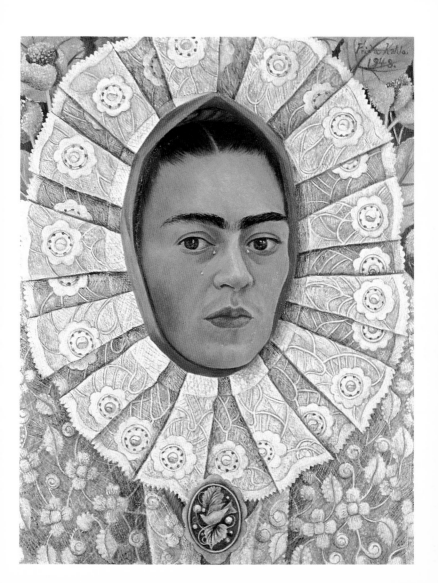

Self-Portrait, 1948
(Autorretrato)
Oil on Masonite, 50 x 40 cm
Private collection

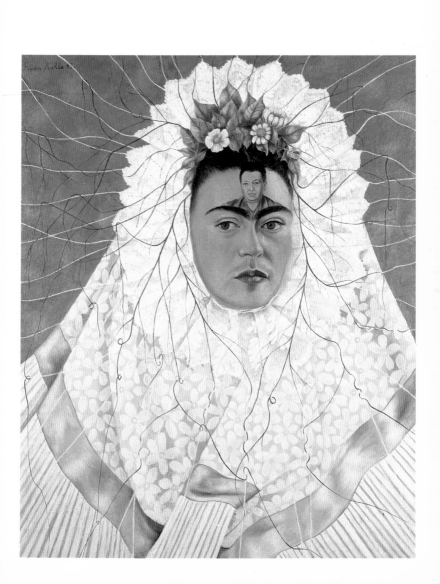

Self-Portrait as a Tehuana (Diego in My Thoughts), 1943
(Autorretrato como Tehuana o Diego en mi pensamiento)
Oil on Masonite, 75 x 60 cm
Jacques and Natasha Gelman Collection

Frida, the Casa Azul, 1941
Photo: © Emmy Lou Packard

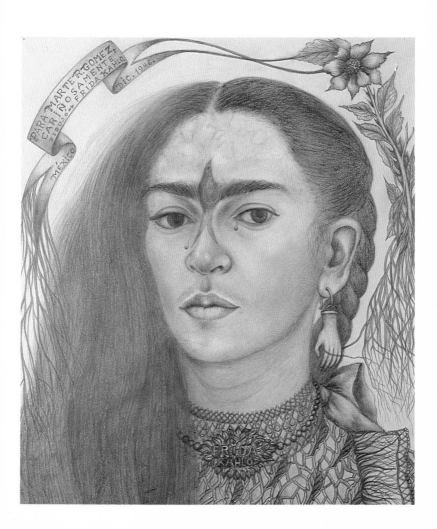

Self-Portrait Dedicated to Marte R. Gómez, 1946
(Autorretrato dedicado a Marte R. Gómez)
Pencil on paper, 38 x 32 cm
Collection of Marte Gómez Leal, Mexico City

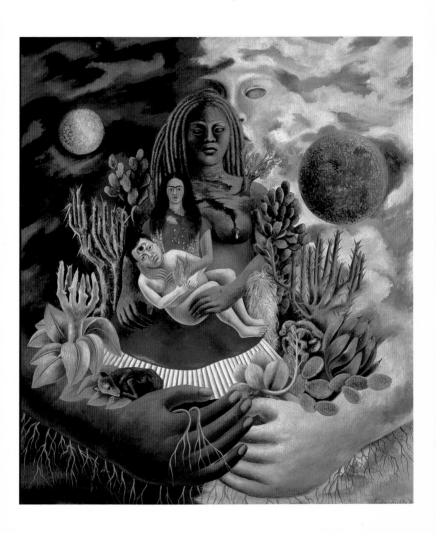

The Love Embrace of the Universe, the Earth (Mexico), Me,
Diego, and Mr. Xólotl, 1949
(El abrazo de amor de el universo, la tierra (México), yo,
Diego, y el señor Xólotl)
Oil on Masonite, 70 x 60 cm
Jacques and Natasha Gelman Collection

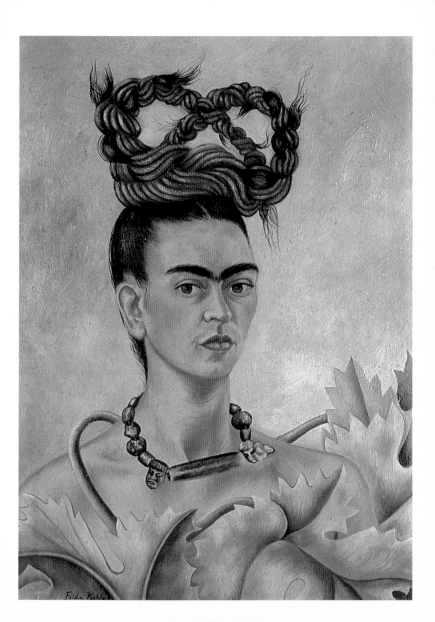

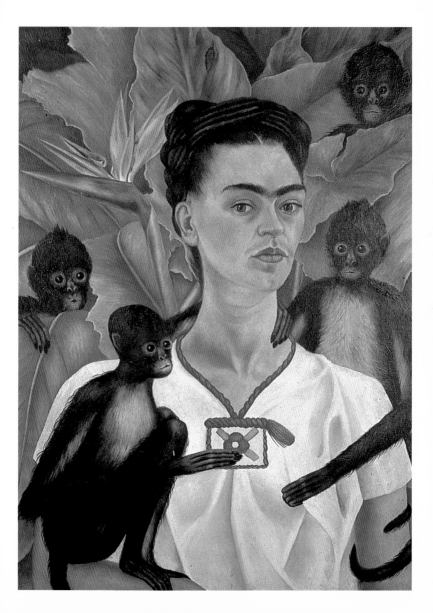

Self-Portrait with Monkeys, 1943
(Autorretrato con monos)
Oil on canvas, 81 x 63 cm
Jacques and Natasha Gelman Collection

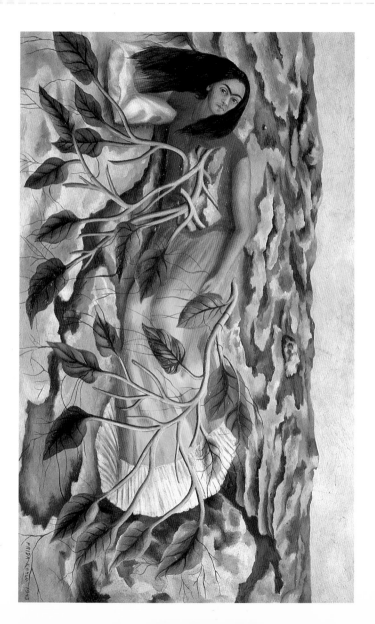

Roots (The Pedregal), 1943
(Raices o El pedregal)
Oil on metal, 30 x 50 cm
Private collection

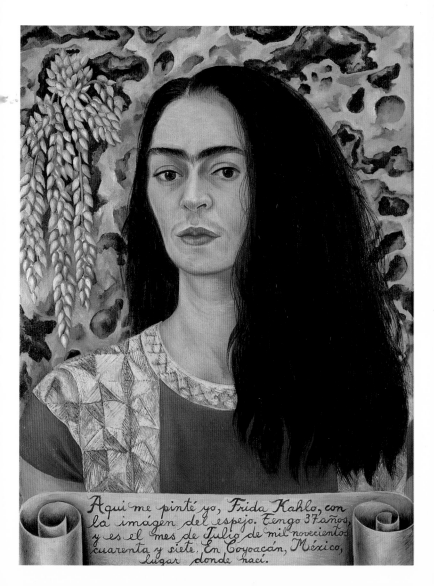

Aquí me pinté yo, Frida Kahlo, con la imágen del espejo. Tengo 37 años, y es el mes de Julio de mil novecientos cuarenta y siete. En Coyoacán, México, lugar donde nací.

Self-Portrait with Unbound Hair, 1947
(Autorretrato con pelo suelto)
Oil on Masonite, 60 x 44.1 cm
Chrysalis Foundation

Self-Portrait with Portrait of Dr. Juan Farill, 1951
(Autorretrato con el retrato del Dr. Juan Farill)
Oil on Masonite, 41 x 50 cm
Private collection

Frida wearing decorated plaster cast c.1950-51
Photo: © Juan Guzman

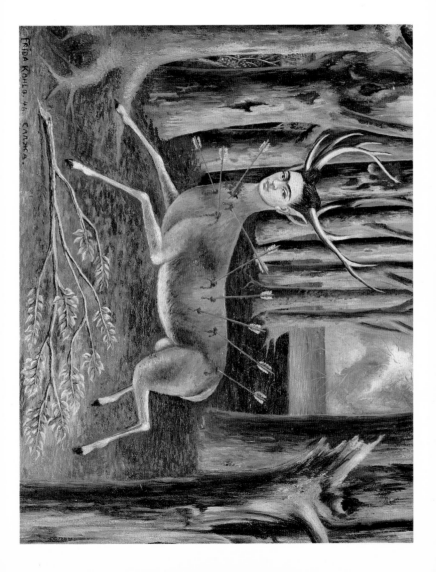

The Wounded Deer (The Little Deer), 1946
(El venado herido o La venadita)
Oil on Masonite, 22 x 30 cm
Collection of Mrs. Carolyn Farb